AT
THE
HEMS
OF THE
LOWEST
CLOUDS

This book and the resident artist fellowship at SAR were supported by the Dobkin Family Foundation.

To my father, and all people who care about the health of our planet

AT THE HEMS OF THE LOWEST CLOUDS
Meditations on Navajo Landscapes

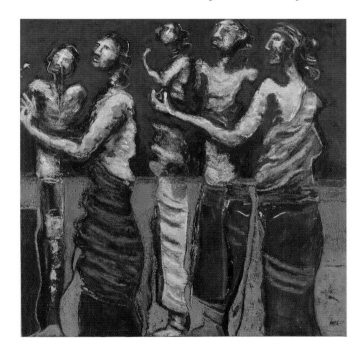

Gloria J. Emerson

School of American Research Press
Santa Fe

School of American Research Press
Post Office Box 2188
Santa Fe, New Mexico 87504–2188

Director: James F. Brooks
Editors: James F. Brooks & Jane Kepp
Designer and typographer: Katrina Lasko
Production manager: Cynthia Welch
Printed and bound by C & C Offset Printing Co., LTD.
Library of Congress Cataloguing-in-Publication Data:
Emerson, Gloria J.
At the Hems of the Lowest Clouds:
Meditations on Navajo Landscapes/Gloria J. Emerson.
p. cm.
ISBN 1-930618-23-9 (pbk.:alk. paper)
1. Navajo Indians—Poetry.
2. Landscape—Poetry. I. Title
PS3555.M4A85 2003
811'.54—dc21 2003045665
Library of Congress Catalog Card Number 2003045665
International Standard Book Number 1-930618-23-9
First edition 2003

Printed in China

CONTENTS

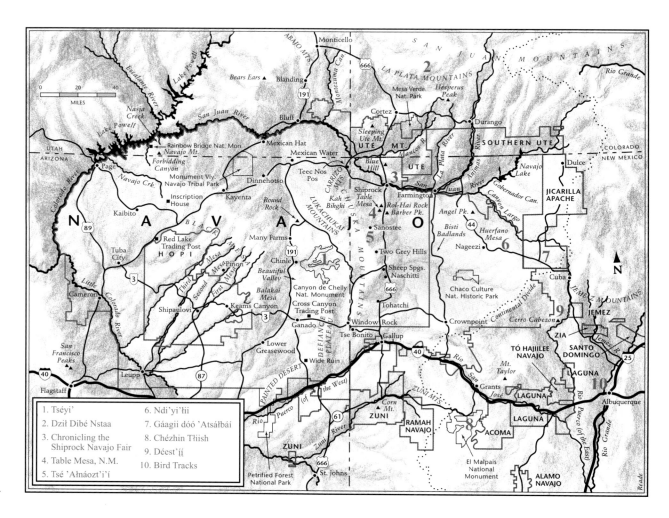

1. Tséyi'
2. Dził Dibé Nstaa
3. Chronicling the
 Shiprock Navajo Fair
4. Table Mesa, N.M.
5. Tsé 'Ałnáozt'i'í
6. Ndi'yi'łii
7. Gáagii dóó 'Atsáłbáí
8. Chézhin Tłiish
9. Déest'íí
10. Bird Tracks

Foreword When I first heard Gloria Emerson speak, I recognized her spirit. It wasn't *what* she said, though certainly what she said was important (she is not given to speak of unimportant things); it was the dignity and self-possession with which she spoke, and it was the profound silence from which her words emerged. I am talking about an attitude toward language, a respect and reverence that is altogether rare in the modern world. In order to have such an attitude, one must listen to the silence, one must understand that silence is the matrix of language. One must understand the sacred aspect of words and the original, creative nature of story and storytelling.

Gloria Emerson has that understanding. She is Navajo. The understanding is an essential part of the definition of the Navajo mind and spirit. Yes, I know you, I thought. I have heard your voice on the canyon walls, in the silence of the stars at Lukachukai when I was a small boy, and the music of Diné bizaad hovered about me like a soft, insistent wind. I hear you now. Shima!

> At the gray spiraled hills on that desolate road
> I passed an old woman who carried a white sack,
> her long skirt swirled upward
> as she lifted her hand for a ride.

Her gesture like old nodding sunflowers,

whispering from a deep far away.

Same rhythm, same motion,

fading back into distant

phosphorous mountains.

Singing farewell

to those deaf to the songs of sunflowers

nodding in the rain.

The poems in this book are incisive observations of the Navajo landscape. The poet sees with a native eye. Everything in her range of vision is familiar to her; she can name all the places within her world. And it is a world of changing colors, wild majesty, and nearly ineffable beauty. She holds it firmly in her experience. She holds it in exquisite balance on her voice. She is a singer in the ancient and Navajo sense of that word. There is a very fine distinction, if there is any distinction at all, between these meditations and prayer. The poems—songs, meditations—of Gloria Emerson are among the most reverential in modern literature. One reads them on the page, but one also hears them; they have the sound of song and prayer. They issue directly from oral tradition and from the sacred place of origin. They are the utterances of creation, old as the chanting of the Yé'iis.

The paintings, too, are informed with reverence and originality. The colors are the colors of *Diné bí keyah*, the earth encircled by the sacred mountains. The figures are starkly animated, with the resistance of parietal art. They seem the figures of masked dancers, or spirits fixed in a dimension of timelessness.

Perhaps it is best not to speak too much about these words and images here. They have to be seen and heard to be believed. *At the Hems of the Lowest Clouds* is a celebration and a gift of the gods.

N. Scott Momaday

Preface There are places on or near the Navajo reservation that beg to tell their stories. Not knowing the Navajo place myths of these certain places, I made up stories for them. Originally, my myths of place were private and personal. As I worked on them, however, I felt the stories needed to be explored in different dimensions, so I began to paint abstractions using sands from these certain places. Using sand helped "ground" the visual pieces as well as reference our Navajo tactile traditions of sand painting. These visual forms are secular. I created poetic forms that neither conform to nor resemble traditional Navajo oratory. I hope my personal place myths do not offend Navajo cultural purists. If so, let me be absolutely clear. I love nihi Diné bahané in its many forms:

- Hajíínáí bahané—emergence stories
- K'é bahané—clan origin stories
- Naaldlooshii hané—animal stories
- Place names
- Stories of our Nation's epic return from Hwéeldi, or Bosque Redondo
- Allegories of our connections with constellations, wind, earth, fire, and water; stories of place and space

I intend my work to salute the rich and great traditions of Navajo storytelling, to contextualize the creative impulses that gave rise to these place myths. I therefore employ the following themes.

Mythologization: Rules for Creating New Myths

Ritual knowledge originates from the sacred teachings of Diyiin Diné, the holy people. Ritual initiation, fasting, prayers, songs, dreaming, and vision quests aided and abetted by our holy teachers opened cosmic doorways. One did not invent myths for individual, self-centered purposes. For example, we didn't invent butterfly or dragonfly symbols; these icons were given as gifts from the holy people. Today's Indian aesthetics follow far different rules. Current iconography might spring from historical events, family repositories of oral aesthetics, or one's own creativity. My secular stories of place leaked out of *unsanctified recesses* of my brain. And although I value *ritual knowledge*, I am not privy to the *ritual knowledge* of the traditionalists; that body of wisdom is scarce in Diné religious contexts as elders move on. Then there is another oral story aesthetic, which is embodied in the "fun" secular stories told to teach as well as to joke and make people laugh.

Tsé'Áwózí: Star Pebble Connections

I have this *thing* for tsé'áwózí (pebbles). I pick up tsé'áwózí in the badlands behind Tuba City, Arizona, in the Bisti, New Mexico, on Route 64, New Mexico, in Dził Sisnajíníí, Colorado, in Dził Dibé Ntsáá, Colorado, at Tsé't'áá'káán, New Mexico.

I believe these humble pebbles made epic journeys from star constellations.
Fire, wind, water, and tumultuous events helped shape their little bodies.

Tsé' áwozí thrust from the mouths of star walkers;

star travelers left eyes when they stopped here;

angry star threw diamonds and gravel about.

The poems of *Table Mesa* and *Déest'įį* were shaped around these themes.

Hidden Landscapes

We race through this land deaf to the echoing sounds of history, glacial grinding within the stomachs of mesas, jungles drying up like rattlers in the Bisti, embattled reptilian monsters gasping for air in the bowels of the lava lands. Rock fracturings recall the violence of meteors slamming into Arizona and grotesque mammals running as shadows in howling dust storms.

And we ignore the spirituality of place and the orthographies layered millennia upon millennia, ignorant of the wisdom that walks in the mountains, of knowledge that runs in the canyons, of stories that run like rivers.

Sacred Spaces

All places are sacred: air, earth, water...my father said the place where water travels is sacred, where corn grows is sacred, where wind tunnels, these places

are sacred. And so it is. Certain places attract prayer sticks, cairns, petroglyphs. They are places in which to lie prostrate on the ground before the presence of the great creator, in which to salute the cardinal directions, the pathway of the sun. Instantaneous sightings of eternal light pass through tunnels into our vision, signals from stars, the sighing of birds in flight. There are places where medicinal plants grow, where trees grow. All places are sacred.

Oral Language: Navajo

Last summer I heard Mike Mitchell, hataałii (medicine man), speak at Tsailé, Arizona, of the holiness of the first word rising into primordial existence. Tears welled in our hearts as we listened to him recount the miracle of language being born. Other Navajo speak of the holiness of saad (word) forming as a rainbow in our mouths. Contemporary Diné educators speak passionately about saad as the essence of life.

My earliest memories of Navajo oratory are from the 1940s, set in cool nights of n'dą́ą́ time: star blankets, smoke from campfires wrapped around sleeping families. Speaker after old speaker orated expansively into the night, rekindling old history between song-and-dance-set pauses.

I do not orate in Navajo. Few old-timer orators are left—hence the fragility of indigenous languages on this continent. With the fading of these languages, so, too, fade the old oratorical styles of grace, posture, gesture, nuance. Winters in

the hogan were the centering time for passing history and stories intergenerationally. Now, storytelling time has been replaced by DVD viewing.

Taboos

Certain taboos govern storytelling. Winter stories are not told out of season, because to do so risks waking sleeping deities—lightning, snakes, bears—who must not be disturbed from their sleep.

Holy Twins and Monster Slayers

Chézin tłish is an archaic ceremonial name for volcanic lava serpents. I use *chézin tłish* as a metaphor to reference ancient battles and the slaying of yéiiítsoh (monsters). Their blood poured through the valleys as lava, through areas now known as El Cabezon Peak, as El Malpais, New Mexico, as the volcano and lava cliffs of Albuquerque. The geologic chapters of earthly violence, eruptions of volcanos, these lava-lands are now home to lizards, rabbits, birds, and temporal peace. Volcanic tunnels bore into the homes of spiritual deities, and these lands house sacred orthographies—petroglyphs. Languages of sacred places resonate from inner-outer zones depicting horned sheep, antelope, bird tracks signaling the migration of sacred journeys, pathways between stars, sun, moon. Yé'iitsoh Bidił Niníyęęzh is where the giant's blood stopped flowing.

Tséyi' Canyon de Chelly, Arizona, is a tourist
attraction where Navajo oral history tangles
with United States military history. I used
the simile of four epochs of Diné creation
stories: First, Second, Third, and Fourth worlds;
color coded as black, blue, yellow, and white
worlds—abstract panoramic views.

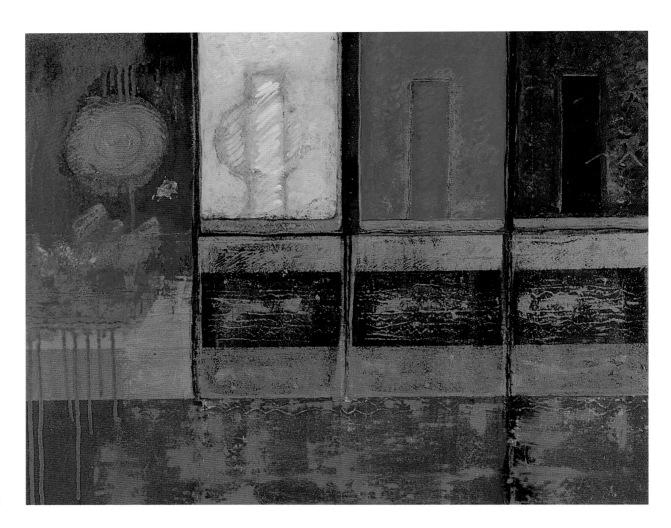

2

Tséyi' When the first dawn people appeared,

a red line zigzagged about them.

Quarrelsome monsters dominated the darkened world,

always in discord.

They thrust angry claws into skies

and shot arrows and epithets at the star families.

And the star families shouted back.

Amidst the turmoil,

the red earth split into red canyons

and the monsters' red arrows froze into spires.

At last, a new dawn family,

Hayoołkaał Diné é appeared,

bringing a blue hazy peace,

and the matriarch Spider picked a spire as hers.

Nearby, Diyiin Diné é hammered star patterns

onto ceilings of sacred caves.

3

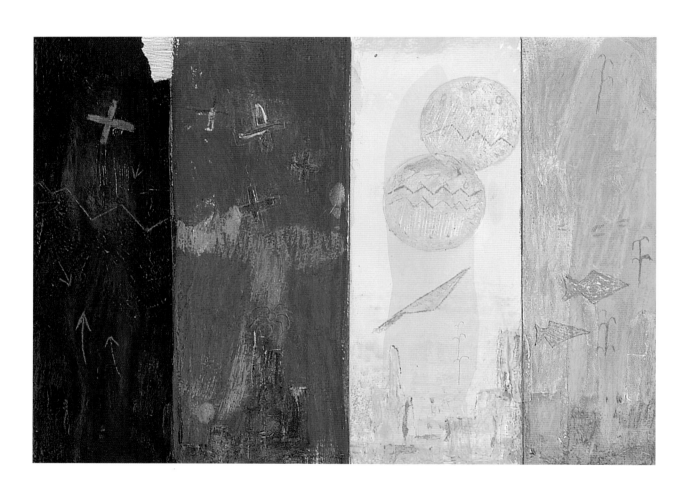

4

In time, war shields ascended,

ushering in a yellow ochre dawn.

The world was once again filled with quarrelsome monsters.

Old grandmothers chanted war songs,

young daughters shed tears as they sharpened knives,

grandbabies huddled

in the deepest crevices of the red canyon walls,

guns flashed into a hail of spears and arrows,

thunder crashed and scorched the spines of the cornfields.

Then a coral arrow dawn group

appeared over cornfields green,

red waters streamed past old red spires,

obsidian arrowhead hovered on a canyon shelf,

deer tracks floated across a spider path bridging chasms,

following male north to female south,

and blue bird nipped the wings of another blue bird.

A woman from Maine took pictures.

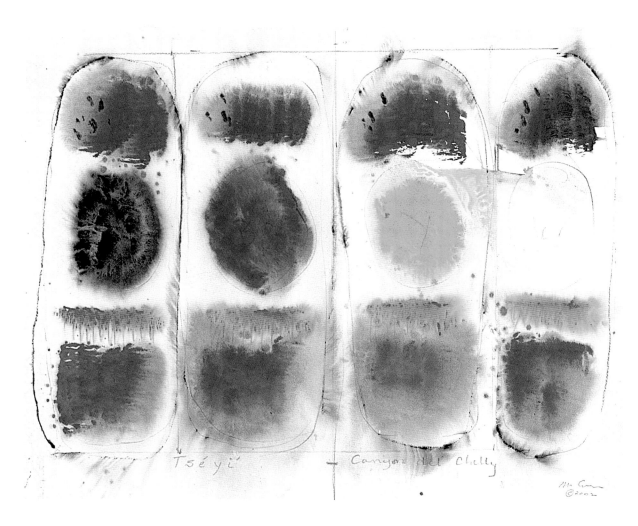

Tséyi' ⟶ Canyon del Chelly

6

Notes

Tséyi'	Canyon de Chelly
Hayoołkaał Diné é	Dawn People
Diyiin Díné é	Holy People

Dził Dibé Nstaa Sacred mountains encompass Diné land.
The outer mountains are chief mountains.
Dził Dibé Nstaa, the northernmost mountain,
is in Colorado. Some say this was where the
primordial Navajo emerged. Others describe
a place now underwater at Navajo Dam, New
Mexico.

Dził Dibé Nstaa Praise be trees in all their

fancy dance dresses—

lime greens, aspen yellows, reds and oranges

blazing down long skirts to hemlines,

bordered by garlands of náábįį

who nod to the rhythm of waters.

Looking for holy ones in the streams

flitting over stones, gems, minerals,

keepers of ancient memories,

eyes catch the dancing lights

of sky and blazing mountains.

Straining to read the lore and poetry

of these living shrapnels from violent ages.

Great birds stitch the spirituality of 'soft-good' skies

to the flame of green feathers,

standing so tall, so high on her waving crests.

Straining to decode tonal pauses,

languages that belong to no man, clan, or tribe.

Sonnets spoken by wind to trees,

by trees to grasses,

by grasses to dragonflies,

by dragonflies to bluebirds,

by bluebirds to frogs.

Yoołgai 'Asdzáán presides over sweet herbal scents

tumbling down waterfalls to beaches

of oxides, coppers, of jasper, and jade.

Dedicated to Joanna and Alexandra

Notes

nááb̜įį	osha, a medicinal plant
Yoołgai 'Asdzáán	White Shell Woman

Chronicling the Shiprock Navajo Fair

I am sad to see the frivolity of ferris wheels and artificial lights juxtaposed with the hallowed grounds of the Yé'ii bicheii. Yé'ii bicheii are human impersonators—certain holy deities.

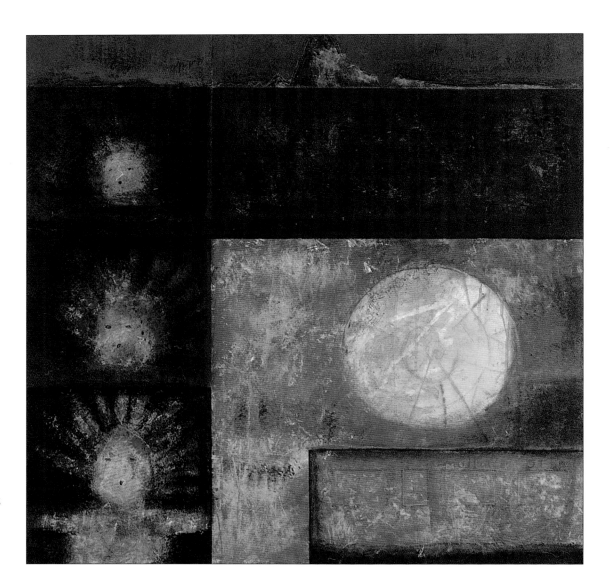

16

Chronicling the Shiprock Navajo Fair

Early Afternoon

In the darkened hogan, an altar is laid,
a patient is blackened,
men begin to sing and sing
until the earth sucks out his sickness.
At last, old father coughs out a grief
that twisted his mind into barbed wire,
and his grief flew out
into the flying grasses.

Mid-afternoon

In the bronzing mid-afternoon
a camp of ants slant skinny legs
into torrents that pound holes
in the pyramids
they had visualized all summer.

17

18

Late afternoon

Winds reverse,

turn and fly eastward now,

with greater passion,

scrubbing sands and river stones

that line the periphery

of cataract visions.

Dusk

The winds claw the farm elms,

the rinsed-off earth sends out a quaking voice

about inner mountain shifts

in a language we no longer understand.

Early Evening

Ants pinch out nocturnal prayers,

re-enacting long nights of dance

insect/cest

that they carry in little sacks while their cousin moths

frenzydance with fire

their shadows leaping,

like giants against stuccoed walls.

Around Ten p.m.

Cats watch the night shake out wet shawls;

the dog carries the load of the night

on tense shoulders.

His bark rumbles like a cough,

in terror

as he watches the writhing frenzied elms.

Around Eleven p.m.

My mother sings a hymnal

deep from her guttural past,

and we,

two old ladies, listen

to sewing machines stitch threads of dry memories;

the twitching elms ache to rest.

Around Midnight—the Fairgrounds

Young ones watch Yé'ii from ferris wheels,

licking cotton candy bought at dusty carnival stands

at the 78th annual Shiprock Navajo Fair.

Notes

Yé'ii masked gods
Moths—'iich'ą hii—are symbols of temptation and
foolishness, so despicable is their behavior.
Insanity is the punishment for breaking taboos.

Table Mesa, N.M. This rock mesa has many stone faces, molded by their connections to star age, ice age, and stone age. My interest is based not so much on its geological value as on its cosmological wonders—visualizing gravity's violent downward forces, large-scale astral battles, and the pantheon of deities frozen in ungodly exchanges on Highway 666, south of Shiprock, New Mexico.

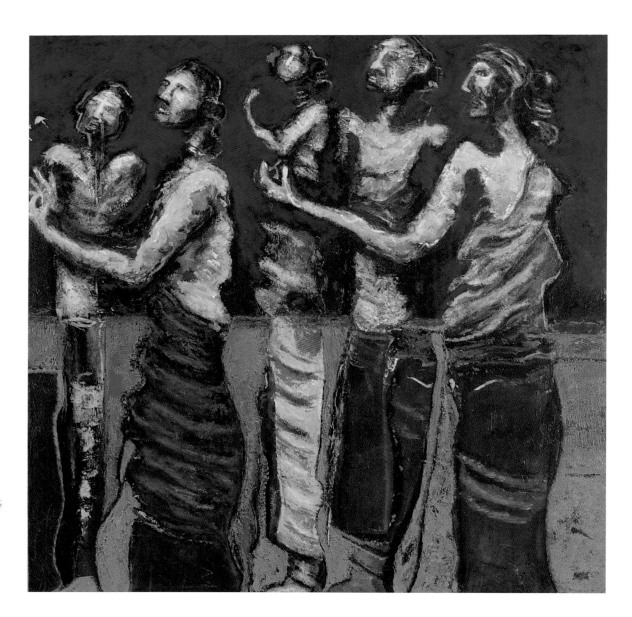

Table Mesa, N.M. Naat'a'í,

creatures of luminosity,

carried glowing bundles of some ancient logic.

They flew in lightning formation

downward

toward a chanting wisdom.

In the murky *under-below*,

a *meanness* flew beneath them,

unraveling the ties,

and with vicious twists

broke open

the flying bundles...

That logic fell and fell

as numbers at first,

which ionized into particles, at first,

and atomized into energy,

and ignited into fire,

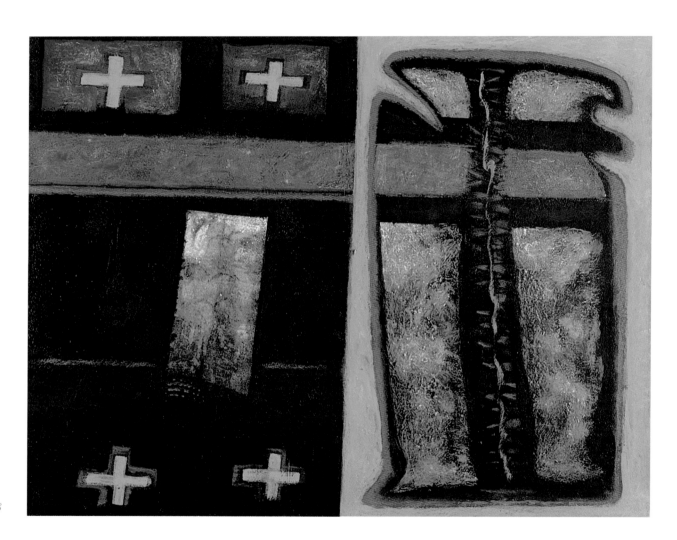

28

and changed the pathways

of certain stars...

star chants, at last!

Sǫ biyiin, sǫ biyiin!

At this point,

das raced forward,

took charge,

embraced the falling songs,

gently guided them downward,

downward to where

sunflowers danced in shimmering yellows.

The songs fell and tablets they became,

forming a wide circle,

embracing the doorway to the east;

the east filled with birds

who flew white as winter, and quivered

with wondrous expectations and creativity.

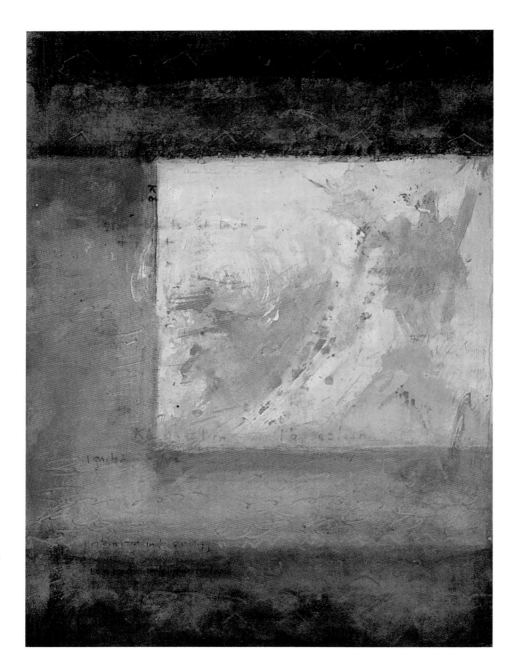

The tablets stood, knelt, stood,

waited and waited.

In time, Hayoołkaał Hastiin found them,

touched them,

and sang…

> *Give your star chants to me*
>
> *Never sing or listen*
>
> *to the drumming of the red stars*
>
> *again*

As one, they defied Hayoołkaał Hastiin.

They sang and prayed

for many seasons

of the wisdom of the natural order,

of the pathways

of kǫ' biná'ooł dah
of Kǫ' Hastiin
of Kǫ' 'Asdzáán
of tácheeh

of songprints
of w'u, w'u,
déłi biyiin,
of first things, first

for within each living form
resides pathways to distant stars,
it is said, jini...

In time,
their songs shuddered into silence...
their prayers petrified
and were suspended
within a zone of ice and stone...

This is where it happened
at this place called Table Mesa.

Notes

naat'á'í	flying creatures
Sǫ́ biyiin	star chants
das	weight, perhaps gravity
Hayoołkaał Hastiin	Dawn Man
Kǫ'	fire
Kǫ' Hastiin	Fire Man
Kǫ' 'Asdzáán	Fire Woman
tácheeh	sweat hogan
w'u, w'u	approximated sound of an approaching diety
déłi' biyiin	songs of cranes
jini	it is said

Tsé 'Ałnáozt'i'í This place is called Sanostee on New Mexico maps. It is located south of Shiprock, New Mexico, en route to Gallup, New Mexico.

Tsé 'Ałnáozt'i'í

At one time

stones rolled about at will,

anywhere,

anytime.

Once a headstone called a meeting,

so the stoned leaders

rolled over

and sat around, sat around, and sat around.

Headstone forgot

he called the meeting

and never came.

Meanwhile gravity came along,

frowned at the sitting stones

and decreed

from thence forward

stones would no longer roll about at will.

39

So there they sit in a row,

overlapping each other's shadows

at Tse' Ałnáozt'i'í.

Ndi'yi'lii Sunflowers spread into the foothills of gray shaled spirally hills between Lybook, New Mexico, and the turnoff to Chaco Canyon on Highway 64. A woman in her late seventies, wearing the traditional clothes of a passing generation, thumbed rides to Aztec from around the area.

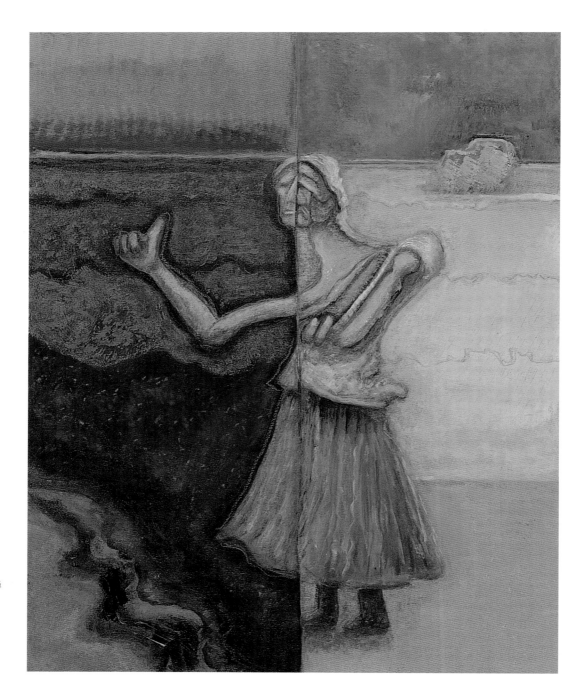

44

Ndi'yi'lii Summer signing farewell.

Sunflowers glowed in the rain.

Young ponds mirrored

the turbulent faces of the sky.

Thunder scolded

and rain children

scrubbed the spines of the divide.

Oh my sister,

the sunflowers glowed

in the rain.

At the gray spiraled hills on that desolate road

I passed an old woman who carried a white sack,

her long skirt swirled upward

as she lifted her hand for a ride.

Her gesture like old nodding sunflowers,

whispering from a deep far away.

Same rhythm, same motion,

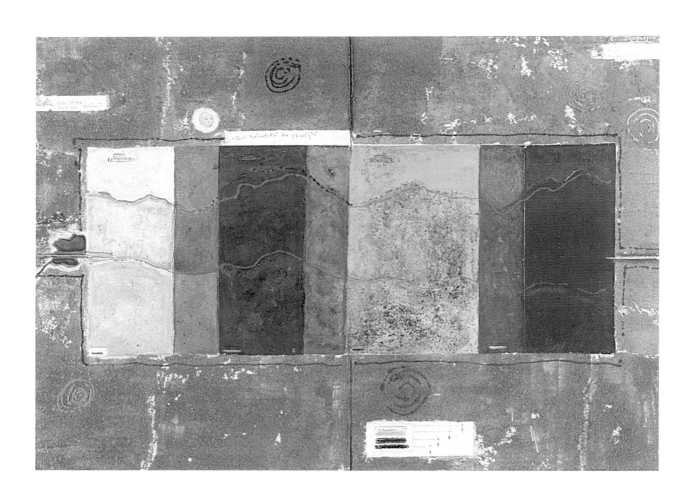

fading back into distant

phosphorous mountains.

Singing farewell

to those deaf to the songs of sunflowers

nodding in the rain.

Dedicated to P. W. Emerson-Tso

Note

Ndi'yi'łíí sunflowers

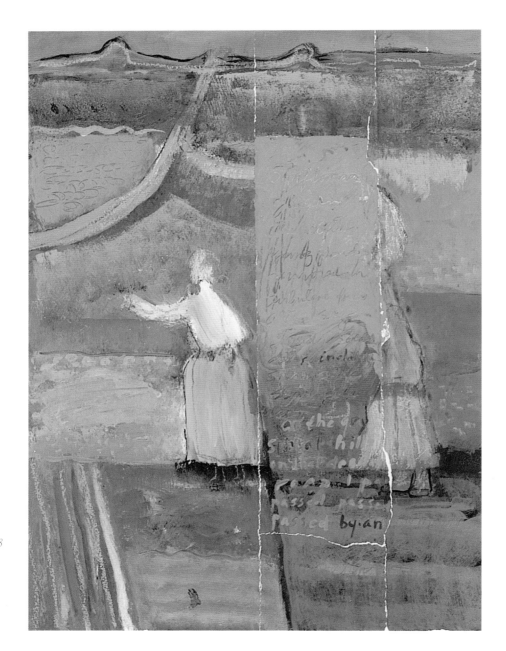

48

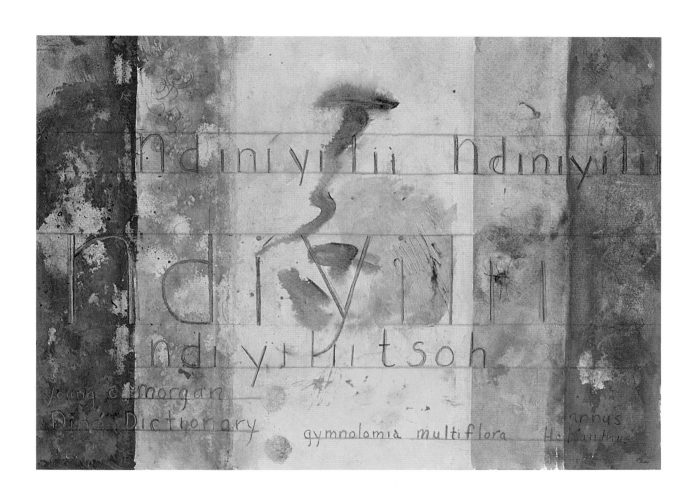

ndiniyilii ndiniyilii
ndiyili
ndiyiłitsoh
Young & Morgan
Diné Dictionary
gymnolomia multiflora Helianthus annuus

49

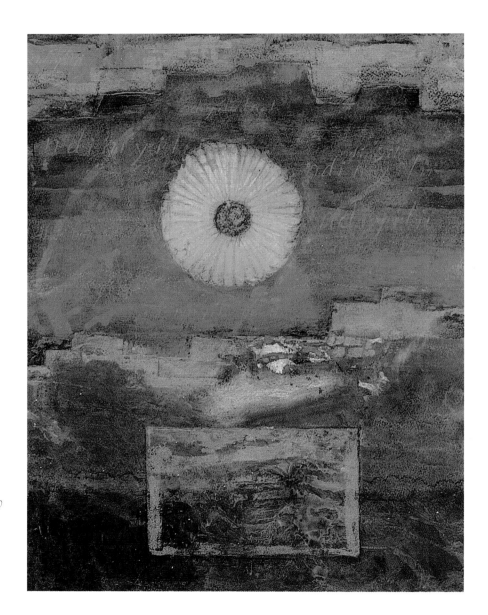

Gáagii dóó 'Atsáłbáí Many times, I traveled through Jicarilla Apache land and passed antelope grazing at safe distances from Highway 64. Falcons observed the landscape from a power line pole. Crows flitted about.

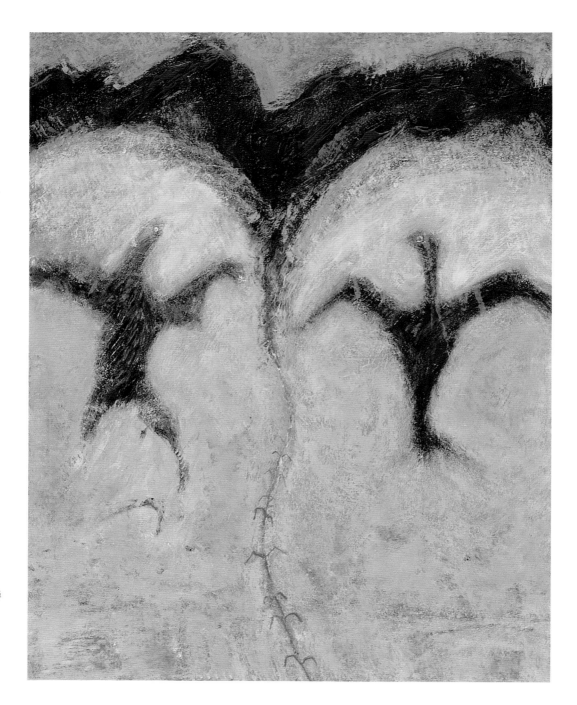

Gáagii dóó 'Atsáłbáí

This land maintains the story

of gáagii,

that tall crow over there,

who divines the history of his clan.

It is his people, you see,

who compete with the falcon sentries

for the right to guard

the hems of the lowest clouds,

which spill rain

like ancient drummings

onto parched drums,

drenching skinny fingers,

which grow into many arms

and become Folding Darkness,

the Twin of Sunrise.

Oh, we stare at this sage place

where jadi used to smile,

at this place where their hills' teeth

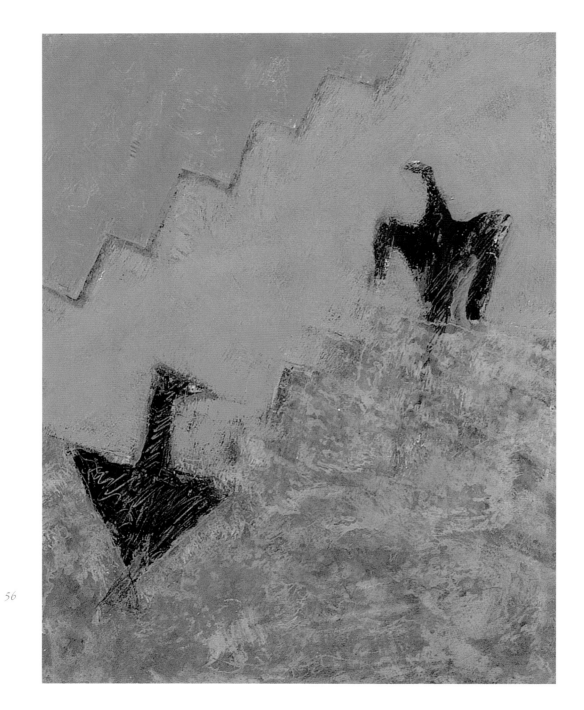

56

got frozen-up into the jaws of time.

Here is where we picked

little clay dishes made by female rain,

before crunching them back to dust,

and it's here where jadi lingered

before fading

into the foothills of loneliness.

Notes

gáagii	crow
dóó	and
'atsáłbáí	prairie falcon
jadi	antelope

Chézhin Tłiish

or

Return of the Monsters

Petroglyph National Monument, west of Albuquerque, and El Malpais, near Grants, New Mexico. It is difficult for me to understand why *CityIgnoramuses* miss the significance of these places of high mysticism. Fat stucco ghettos are springing up around the perimeters of Petroglyph National Park. Mayor Chavez partially paved Universe Boulevard through the northern part of the park to accommodate the rapid growth of Albuquerque's west side and its developers. My niece and nine others were arrested for trying to stop the paving of Universe Boulevard in the fall of 2002.

The Hero Twins were delegated to clear out the ancient homelands of nasty brutish monsters, only to have modern monsters return wearing enemy armor from Dillard's and Sears.

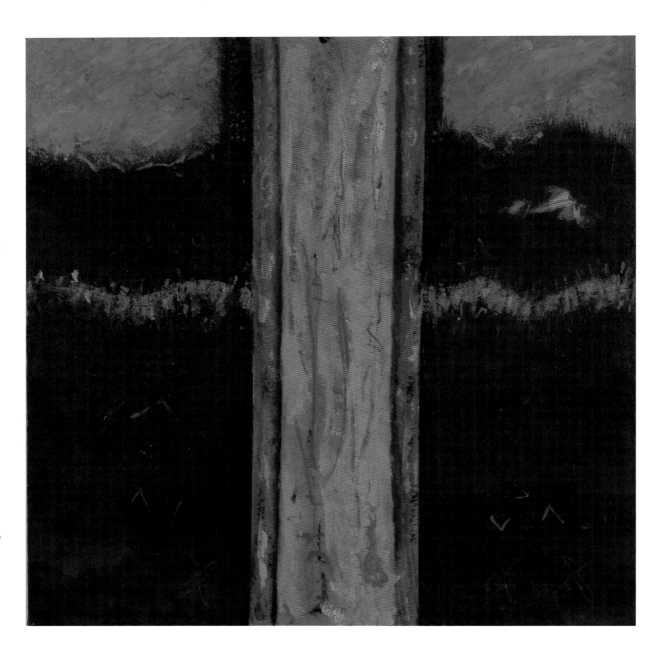

60

Chézhin Tłiish

or

**Return of the
Monsters**

Conceived in the womb of the restless Mother,

monster twins were born and erupted

as ancestral fires and thunder.

Chézhin tłiish sprang forth—

fires became volcanic

vomit pouring into a thousand valleys.

Everywhere firespit streaked about

while thunder shook the skies

over the groaning of mesa mountain shifts.

After many centuries,

the fiery blood cooled into vari-grays of lavic wisdom,

the blood stopped at the toes of Tsoodził

and the Hunchedbacked Mountain of the east.

Tsézhintah is where prayers were chiseled onto faces,

where guttural prayers still echo and gurgle

through volcanic throats...

61

Prayers were offered

so cornstalks would spiral into skies,

bean sprouts would move

like giant shadows along the ridges,

and squash blossoms

would dance in their seasons.

Old winds flute songs as shadows move over the

many faces of the moon, and the river

replenishes the thirst of the great Serpent, lying

north to south.

Old winds flute songs

as gridlines are drawn by new dreamers

who dream of new plunder,

whose visions are driven by freon,

whose wisdom is guided by neon,

and whose rivers run like asphalt.

They, too, chisel prayers onto lottery tickets.

Skyscrapers replace spiraling cornstalks,

unnamed shadows replace bean sprout shadows,

frenzy-dances replace squash-blossom dances.

Here, a thousand trucks rumble past

the restless throats

of sleeping monsters.

Notes

chézhin tłiish archaic ceremonial word for lava snakes
Tsoodził Mount Taylor
Tsézhintah lava rock

Hunchedbacked Mountain is my name and is not based on
Navajo oral tradition.

Déest'íí This word refers to the concept of divination. I think about the petroglyphs as a metaphor and a manifestation of déest'íí, which crosses many boundaries and dimensions of time and space. I think of the petroglyphs in the lavalands in places like west Albuquerque, New Mexico.

Déest'íí *Stargazing*

into the holy belly of breathing,

cornstalks whorling

toward the sacred arc.

Fire tongues flaming south to magnetic north,

and bloodspit turns to sapphire

and gravel

and exploding clouds;

ancient mists beget starry pools and silver oracles;

tails of rivers burst into valleys

like an explosion of stars.

Light waves travel to uplifted faces,

chiseling wisdom

onto leaves of every tree,

onto stalks of every corn,

tassels swaying

with ancient winds breathing

the holy breath of corn pollen boy,

the holy breath of corn beetle girl.

Story talking physics flow as rivers

singing up corn,

singing up kernels of wisdom.

Rising into our vision as cornstalks,

as thoughtclouds

blown to this place

from ancient worshippers

who monitored shadows on the moon side

of winter solstice,

of summer solstice,

 Hoozhǫǫh naháásgłįį

 Hoozhǫǫh naháásgłįį

 Hoozhǫǫh naháásgłįį

 Hoozhǫǫh naháásgłįį

Four times it is spoken

into the holy belly

of breathing.

Notes

déestį́į́ divination
Hoozóóh naháásgłį́į́' Harmony or balance is restored
(many other interpretations)

Bird Tracks The bird track petroglyphs are guides, primordial blueprints, and are a kind of reference still read by certain gifted people in the area.

Bird Tracks These hills have ears

 that translate our every word

 into readings from some volcanic order,

 from some poetic volcanic order,

 rising as proclamations

 every century or so.

Bird tracks inscribe legends of their migrations

 on shadow moving faces,

 on sunstreaking faces,

 protecting old creeds

 written on ionized dials

 scrubbed down by

 rain strokes,

 wind strokes,

 sun strokes,

 time strokes.

These mountains guard

 the hearts of every stone, hill, ridge,

 protecting references of ancient sky ways,

 and ancient wind tunnels,

 protecting laws of the eagle

 who chase primeval winds

 flowing from ancient talking skies

 to these living pyramids and talking valleys...

Bird tracks touching down on escarpments,

 stepping on this face, that face,

 unveiling primordial blueprints.

 Hoozhǫǫh naháásgłįį

 Hoozhǫǫh naháásgłįį

 Hoozhǫǫh naháásgłįį

 Hoozhǫǫh naháásgłįį

A Painter's Notes Visual interpretations of *from Sand Creek,*
Simon J. Ortiz's book of poems.

Sometime in the early 1980s, I read Simon J. Ortiz's book of poetry entitled *from Sand Creek*, originally published by Thunder's Mouth Press in 1981. *from Sand Creek* contains a poet's reflection on a massacre that took place in the southern plains of Colorado in 1864. Ortiz contrasts that massacre with the ongoing injustices experienced by American Indians today. Embedded within these poems were lessons for me about our indigenous past and selves, along with chronicles of inequities, of pain, life, death, and, yes, of grace, hope, and valor.

After that early reading I began doing color sketches—the beginning of a painting series that would take almost two decades to realize. Each time I saw Ortiz I told him I was painting visual interpretations of his poems. I realize now that although the physical manifestations of "my painting" were meagre, they felt nearly full-blown even then. In the early 1990s, I saw Ortiz and again told him I was "painting" *from Sand Creek*. Finally, in the fall of 2000, I saw Ortiz and, for the third time in nearly twenty years, told him I was painting his poems. Ortiz seemed eager to see my works, so I invited him to Shiprock, New Mexico, to my studio in December. I was glad he didn't show up, because the series was not ready for viewing. Through the winter and spring I kept refining the work, until it seemed complete. In April 2001, I decided the paintings were all mediocre, so I looked for a place to work uninterruptedly and moved into the Harwood Studios in Albuquerque, where I spent the summer of 2001.

Ortiz finally saw eleven paintings in early August of that year. I imagined we would have an in-depth dialogue, a visual artist conversing with a poet under a cottonwood tree. But it wasn't a dialogue; it was a viewing—a first and last encounter with the poet.

I didn't hear from Ortiz until I wrote to him in November 2002 informing him that two or three of the paintings might appear in this book and asking for his blessing, which he gave in a simple, generous letter.

I had kept a crude journal, often wondering in it what a Navajo woman was doing interpreting an Acoma Pueblo man's poetic interpretation of a massacre that devastated bands of Southern Cheyenne and Arapaho—it was their history, not mine, I kept saying as I struggled with each painting.

> Footnote: In November 1999, we learned that my sister was dying of cancer. We lived with that knowledge all winter. She died in April 2000. Working on these paintings was a constant reminder of death and dying, and it made my work more difficult.

In the spring of 2002, I was selected to be the Eric and Barbara Dobkin Native Artist Fellow at the School of American Research in Santa Fe, New Mexico. While there, I finalized several works in the series. I put away the largest and most brutal canvas for my own personal study. I sold or destroyed the rest. In all, I interpreted eight poems. Words of these poems were incorporated as fragments into my paintings.

> Footnote: Over the years, I lost the first edition of *from Sand Creek,* so I used a second edition printed by the University of Arizona Press as my reference. The pages given in these explanatory notes are from the second edition. The poems themselves are untitled.

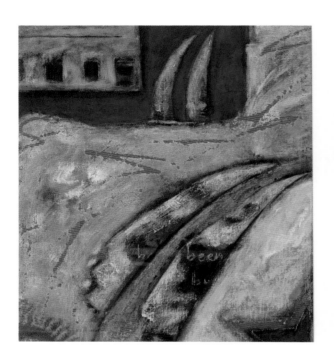 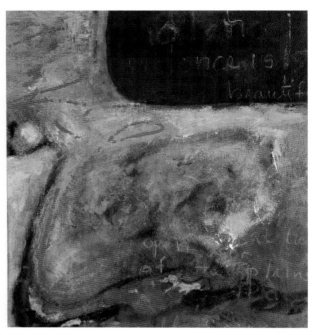

Painting 1, Diptych

(This poem prefaces the book, and the page is unnumbered.
Underlining added by Gloria Emerson.)

What I consider the strongest painting of the series is a
diptych on canvas. The painting interprets these lines:

This <u>America</u>
has been a <u>burden</u>
<u>of steel</u> and mad
death,
but, look now,
there are flowers
and new grass
and a spring wind
rising
from Sand Creek.

Autumn is beautiful in Colorado, like a golden dusk, rich
with smell... (p. 18)

Buffalo were dark rich clouds... (p. 20)

Buffalo ghosts

hurdle away....

They rode like steel,

blades flashing.

Sighs sighs weave grass.

Who watches now? (p. 21)

The words underlined in the preceding passages were incor-
porated into the diptych and are layered, buried, or obliterated
by texture and paint. Few words are discernable to the view-
er. This painting started out as a large canvas that I eventually
tore into four parts. Two parts make up this diptych. The
painting is owned by Joanna Hess of Santa Fe, New Mexico.

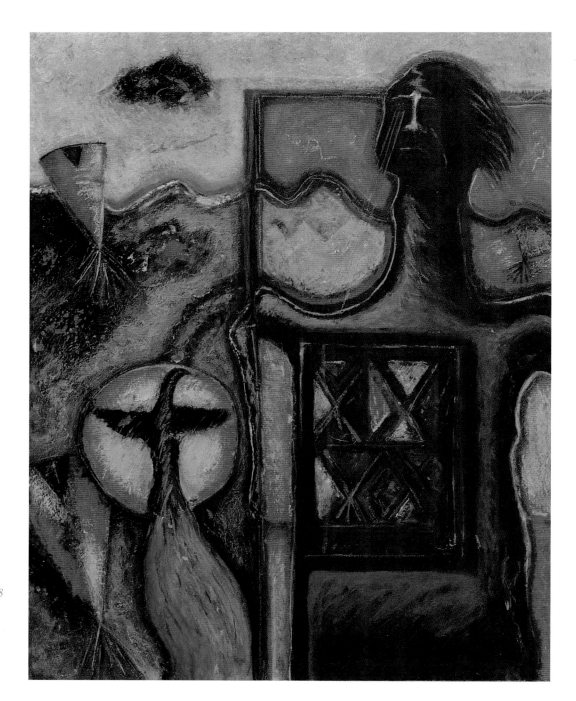

88

Painting 2, about Black Kettle

The second painting is about Black Kettle (p. 79). The icono-
graphy within this painting is decipherable, I think, to the
viewer.

They must have known.
 Surely,
they must have.
 Black Kettle
met them at the door
of the plains.

 He swept his hand
all about them.
The vista of the mountains
was at his shoulder.
 The rivers
run from the sky.

The generosity of this man "opening the door to the plains" is a moving tribute to Black Kettle and thousands of early First Americans who welcomed America's pioneers. Their stories of generosity go untold.

In thinking about the Southern Cheyenne and Arapaho, I resisted the temptation to study their iconography and to incorporate their symbology into this work. I treat their history not as a historian but as an artist and a contemporary Indian woman, one who is not familiar with Southern Plains cultures but nonetheless honors their history. This painting is now owned by Cynthia Welch of Rhode Island. I own another painting of Black Kettle.

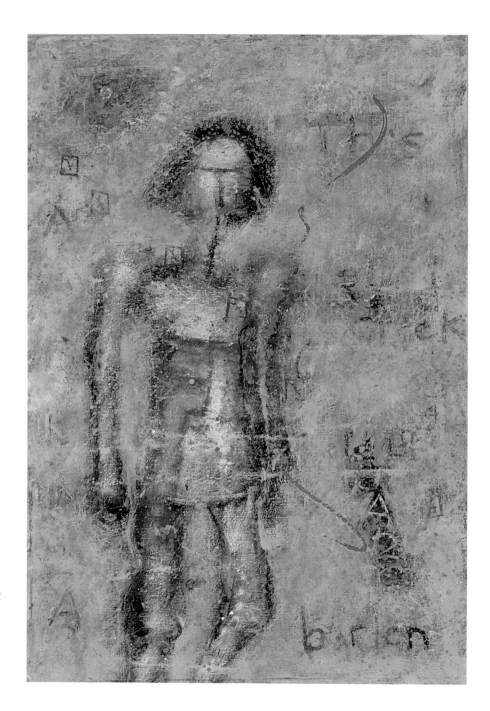

92

Painting 3

The third painting is of a figure, an apparition, emerging
from a yellow sandstorm of history and testifying to the
brutality witnessed. Yellow ochre dust might be from Sand
Creek. The figure wears American icons—the red, white,
blue stripes...

> This <u>America</u>
> has been a <u>burden</u>
> <u>of steel</u> and mad
> death...

The words "America" and "burden" are decipherable within
the painting. I employed other icons. Each red cross
represents a grouping of the 105 women and 28 men who
were massacred at Sand Creek. The painting is owned by
Lucy Noyes and Dick Hopkins of Placitas, New Mexico.

School of American Research Mission

The School of American Research, a nonprofit center for advanced studies,
contributes to the understanding of the human condition by supporting
the study and practice of anthropology and Southwest Indian arts. SAR is
dedicated to building an international and multicultural community of
scholars and artists who seek to deepen our understanding and enhance
our appreciation of human diversity. SAR achieves this mission through
a cluster of interrelated programs whose goals are to advance, promote,
honor, publish, and share the work of such scholars and artists, all in an
environment that fosters communication, productivity, teamwork, trust,
personal development, recognition, and mutual respect.